Santa Fe

Photography by

William Clark Edward Klamm Jack Parsons Bernard Plossu

Aerial Photography by Paul Logsdon
Designed by Howard Klein

PUBLISHED BY FOTOWEST PUBLISHING
SANTA FE, NEW MEXICO
1984

Printed by Graphic Press Ltd., Phoenix, Arizona
Typeset in Galliard by Copygraphics, Santa Fe, New Mexico
Color separated by Colour Control, Phoenix, Arizona
Produced by Karen Evans

FotoWest agency was begun in 1983 in Santa Fe, New Mexico. It specializes in
stock and assignment photography of the American Southwest.

ACKNOWLEDGMENTS

MANY PEOPLE HAVE GIVEN THEIR HELP AND ENCOURAGEMENT TO THIS
PROJECT. THE PUBLISHERS PARTICULARLY WANT TO THANK DAVID HILL
OF THE COLLECTED WORKS BOOK SHOP; VIRGINIA AND WILLIAM
GANNON; RICHARD ABELES; THOMAS CLAFFEY; ROBERT STOKER OF
MARCH PRESS, BOULDER, COLORADO; BUD CAREY OF GRAPHIC PRESS
LTD., PHOENIX, ARIZONA; JEANIE PULESTON FLEMING,
DOUG AND SUE DAWSON, AND LUCY JELINEK-THOMPSON.
SPECIAL THANKS GO TO OUR FAMILIES: LOUISE AND KELLY EVANS,
GERALDINE AND DON GORDY, LUCILLE TYSON AND MR. AND MRS.
ANTONIO GARRAMONE.
KAREN AND EDWARD KLAMM
SANTA FE, JUNE 1984

THE QUOTATION ON PAGE 5 IS REPRINTED FROM PAUL HORGAN'S *THE
CENTURIES OF SANTA FE* WITH PERMISSION (WILLIAM GANNON,
PUBLISHER, 143 SOMBRIO DR., SANTA FE, NM 87501). THE QUOTATION ON
PAGE 39 IS REPRINTED WITH PERMISSION FROM UNIVERSITY OF NEW
MEXICO PRESS, ©1959. THE REMAINING QUOTATIONS ARE REPRINTED
WITH PERMISSION OF THE AUTHORS.

First Edition

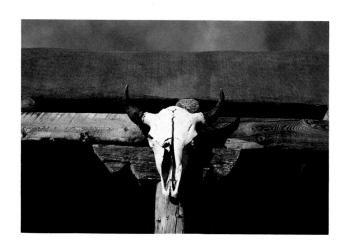

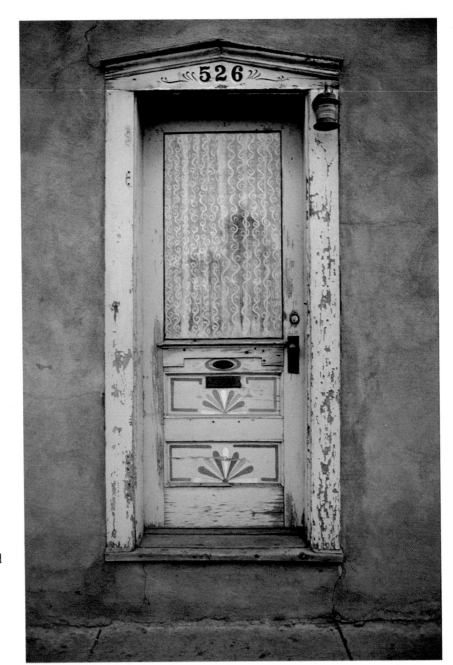

Weathered and painted
door, Canyon Road

It was always difficult to fix upon the particular stimulus amid all the general charms which had most to do with bringing modern colonists to town. Some spoke of the altitude, with its bracing effect; others of the air, the light, the color all about. Yet beyond these something else could be felt. It was an insinuation of freedom in behavior, not in any publicly unsavory terms, but rather in an opportunity for an individual man or woman to live a life of free expression. In modern times, was this the most significant—and perhaps the most Latin—of attractions about Santa Fe?''

Paul Horgan, *The Centuries of Santa Fe*

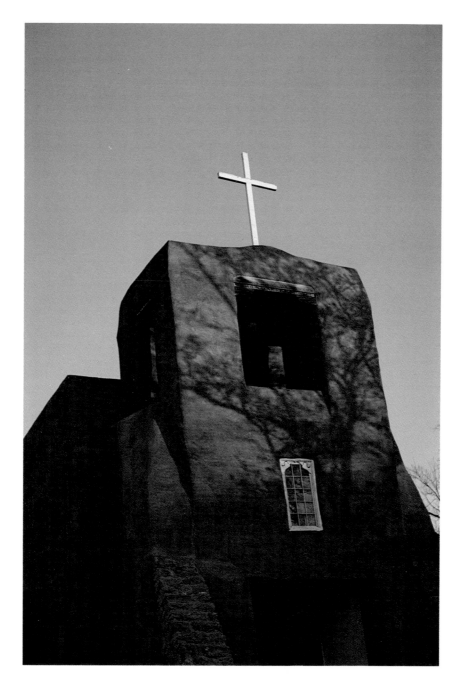

San Miguel Chapel, the oldest mission church in the nation

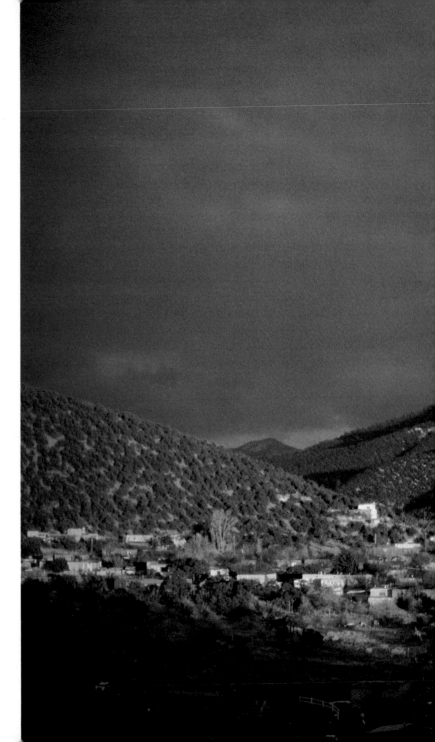

"There is something about the light, the mountains, the clear air, and the barren earth that suggests that if inner peace lives anywhere, this must be the place. The ancient Indians called it 'The Dancing Ground of the Sun.' The conquering Spaniards named it 'The City of the Holy Faith.'"

Robert Mayer

Cerro Gordo area at sunset

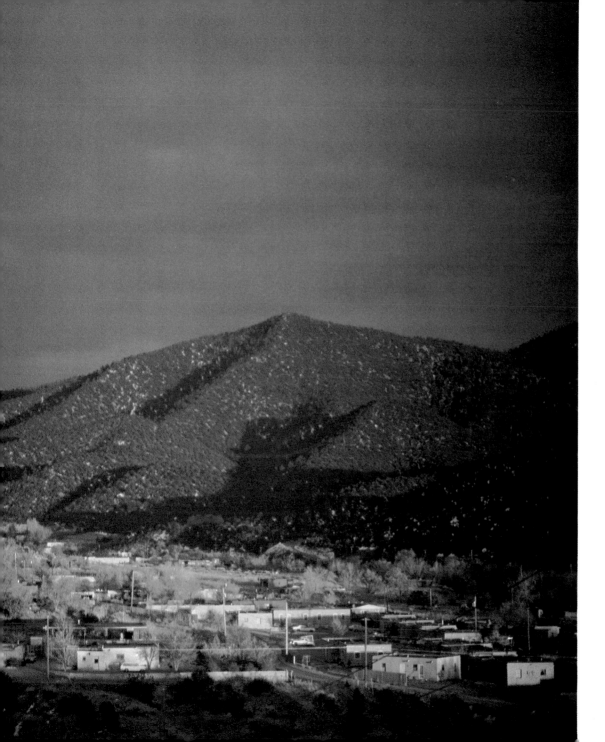

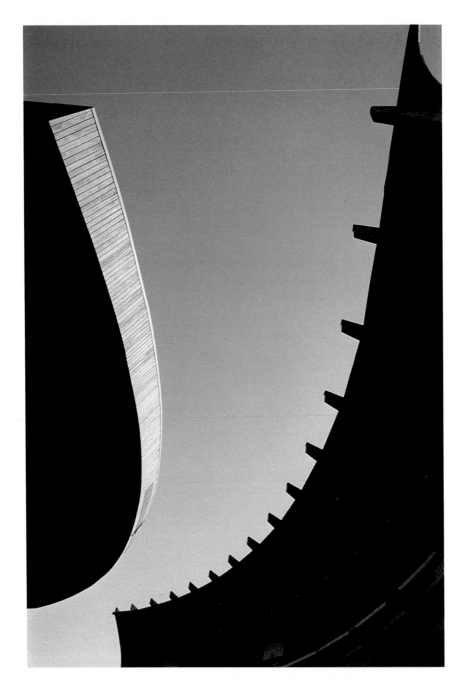

The soaring roof of the
Santa Fe Opera

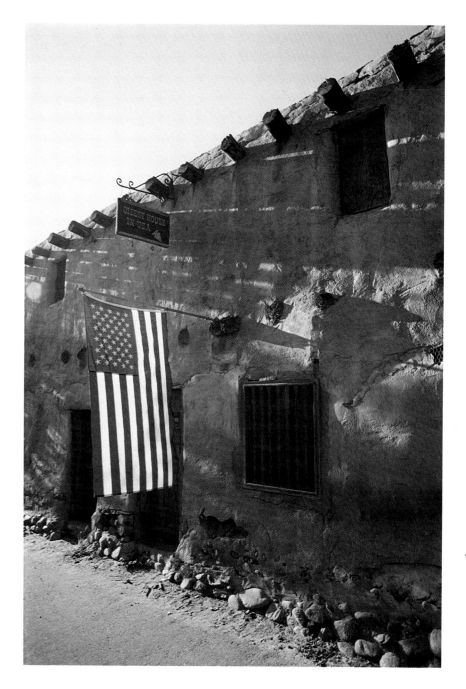

The ''Oldest House''

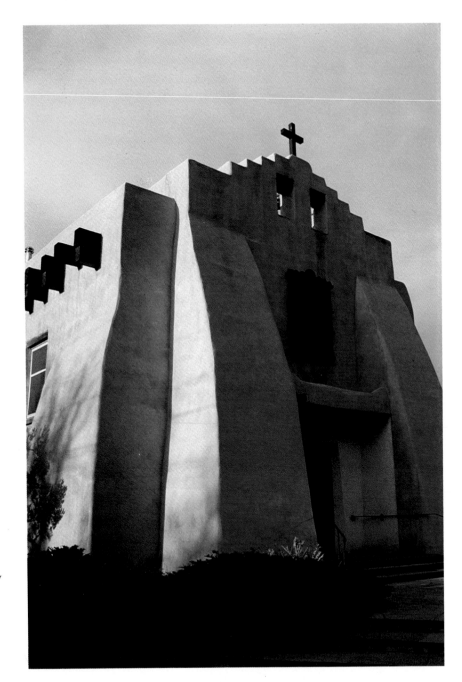

First Presbyterian
Church, designed by
John Gaw Meem

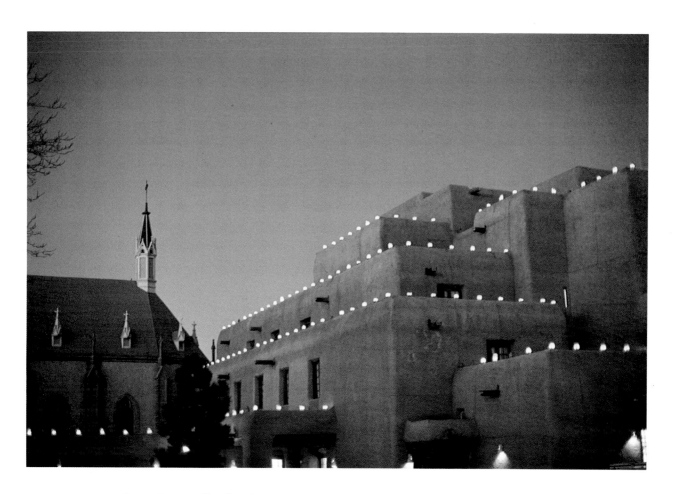

Inn at Loretto lined with
Christmas farolitos

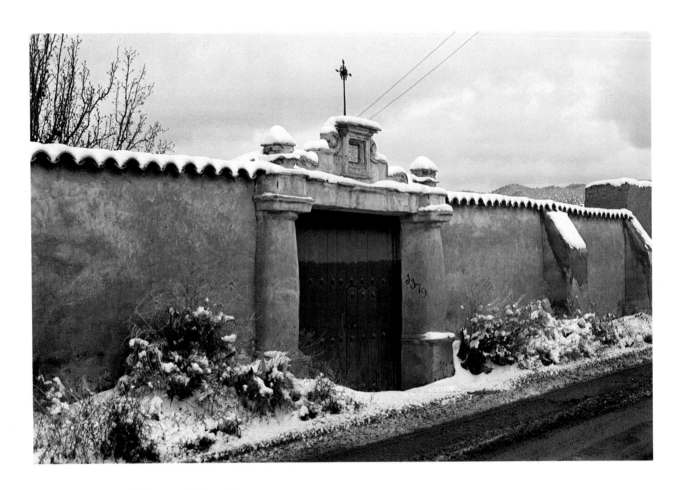

Winter on Upper Canyon
Road

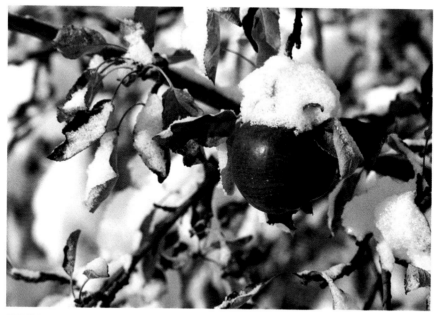

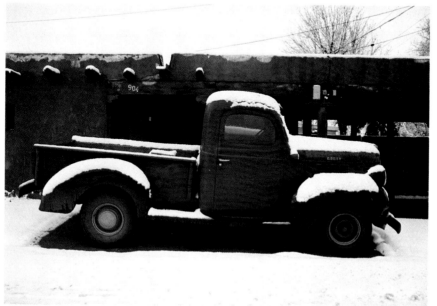

Apple and Dodge truck
in the snow

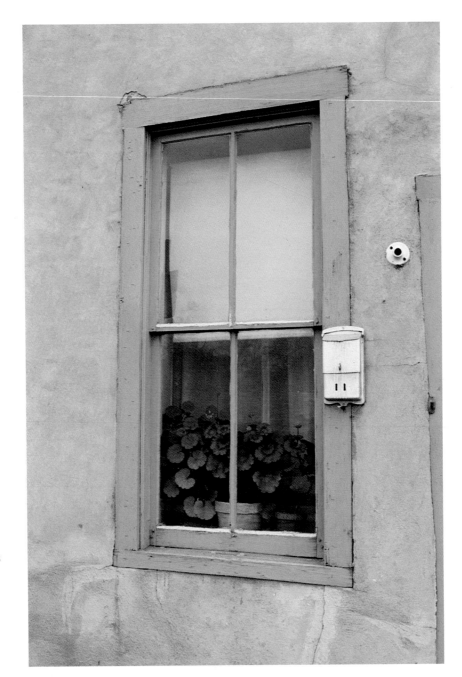

Window and geraniums
on Canyon Road

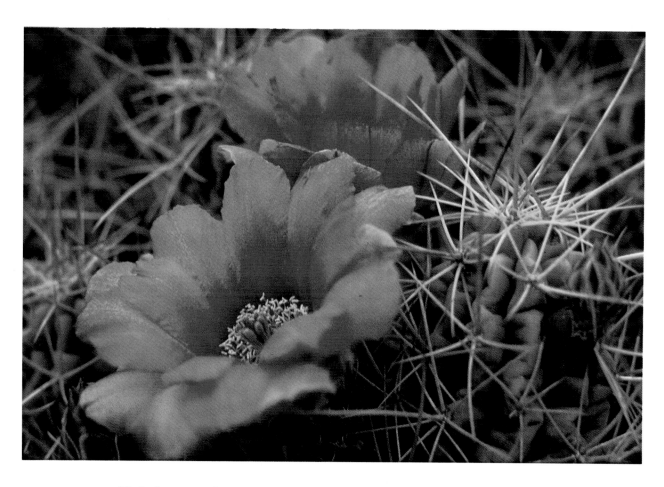

Hedgehog cactus in
bloom

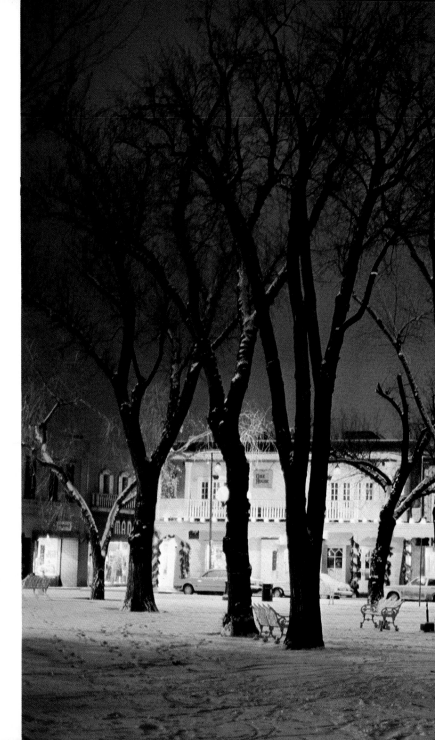

The Plaza, heart of town and the end of the Old Santa Fe Trail, has seen wars and rebellions; feasts and funerals; the soldiers of Spain, New Mexico, the Confederacy and the Union; bullwhackers and caravans; Spanish, Indian, and Anglo; lowriders and tourists. It has also seen solitude.

The Plaza

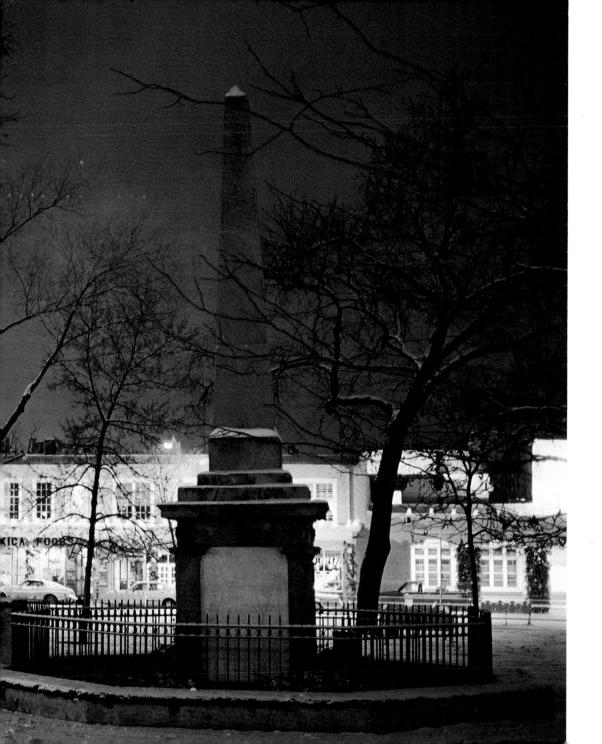

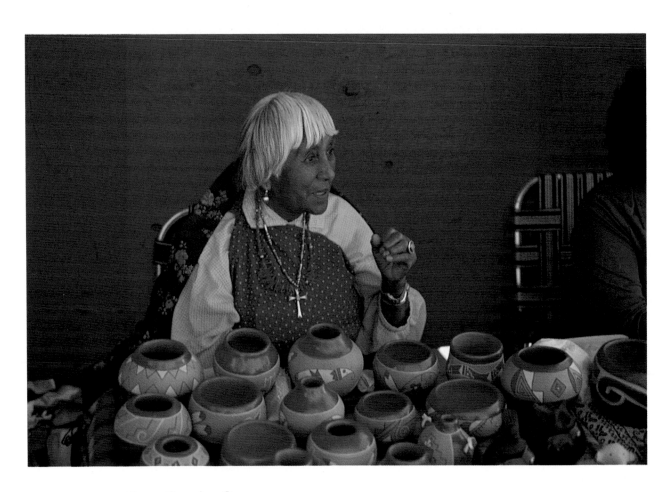

Potter Geronima C.
Archuleta of San Juan
Pueblo at Indian Market

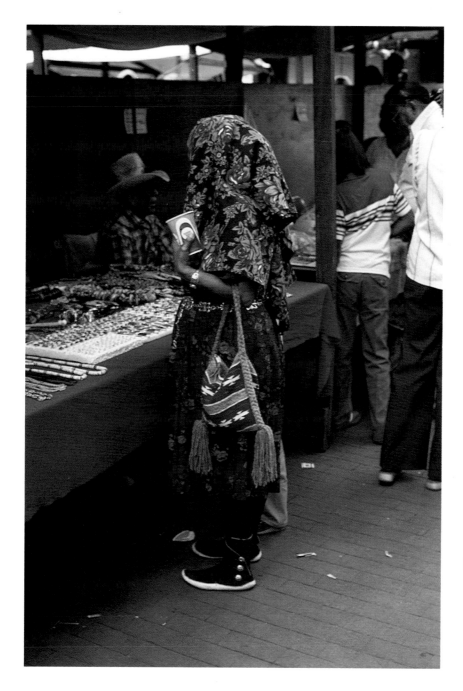

Indian Market

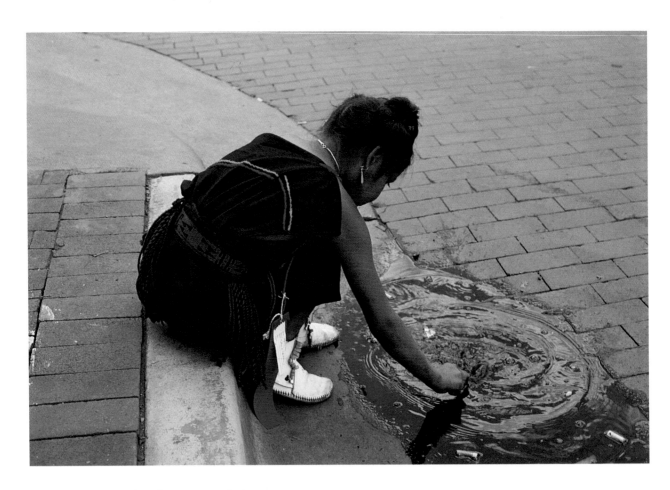

A quiet moment during
Indian Market

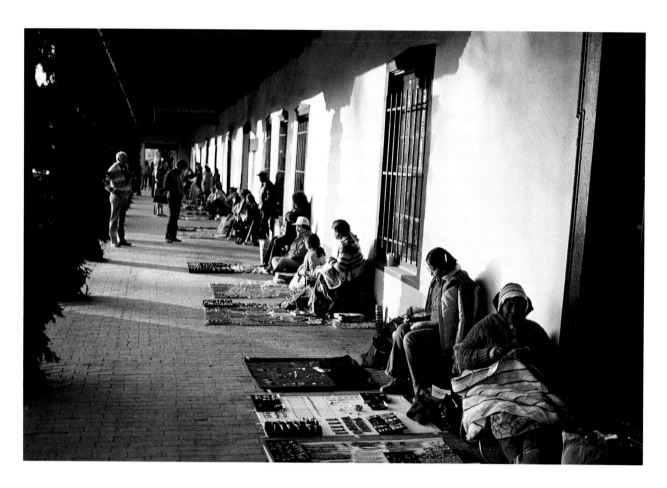

Indian sellers under the
portal of the Palace of the
Governors

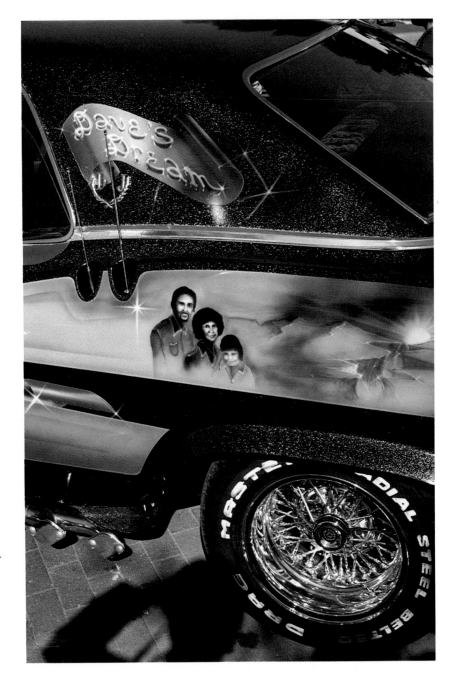

Lowrider car

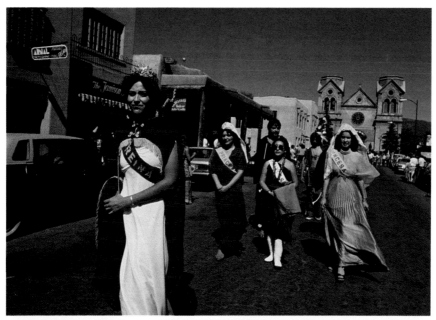

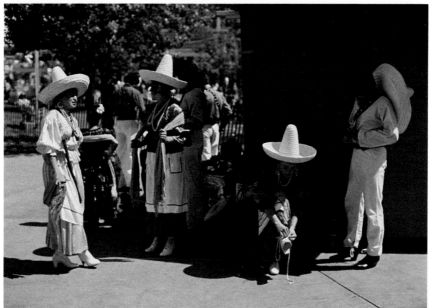

Top: Fiesta queen and her court near St. Francis Cathedral. *Bottom:* Fiesta dancers.

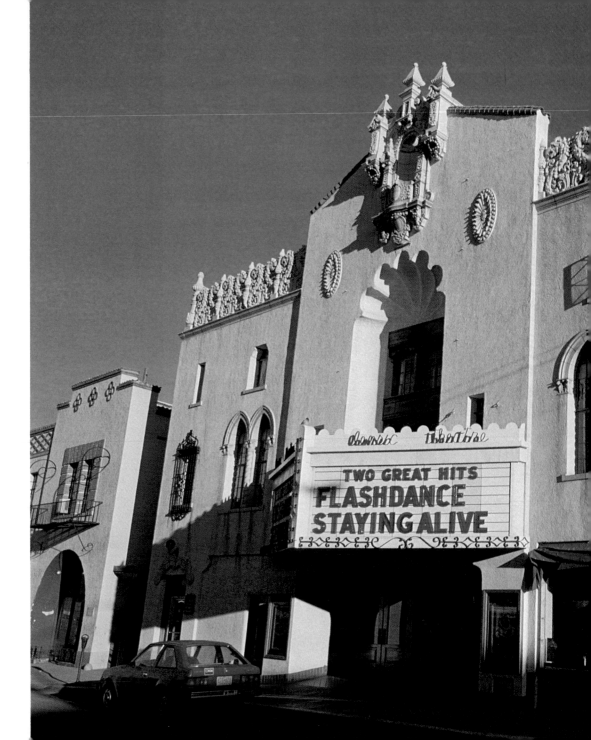

"*Those who stay, I think are held most of all by those two ephemeral qualities of the city: the myths that somehow enrich the atmosphere and the evanescent light that bathes it all.*"

Robert Mayer

Lensic Theatre

East De Vargas Street

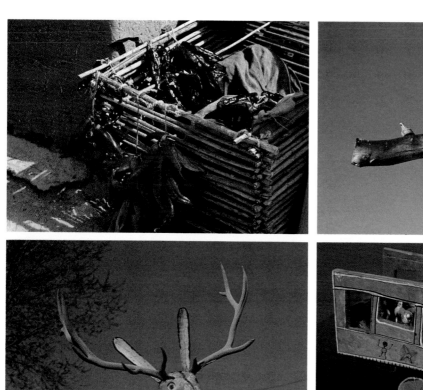

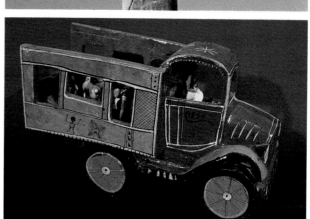

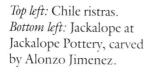

Top left: Chile ristras.
Bottom left: Jackalope at
Jackalope Pottery, carved
by Alonzo Jimenez.

Top right: St. Francis,
carved by Ben Ortega.
Bottom right: Folk art
truck from the Girard
Collection, Museum of
International Folk Art.

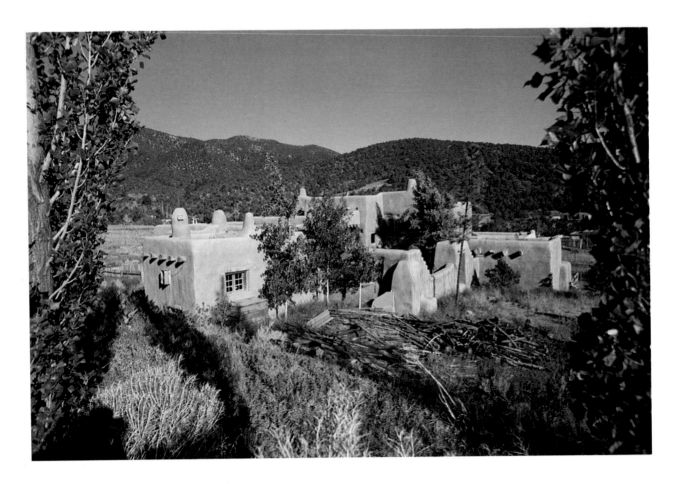

Rambling adobe home

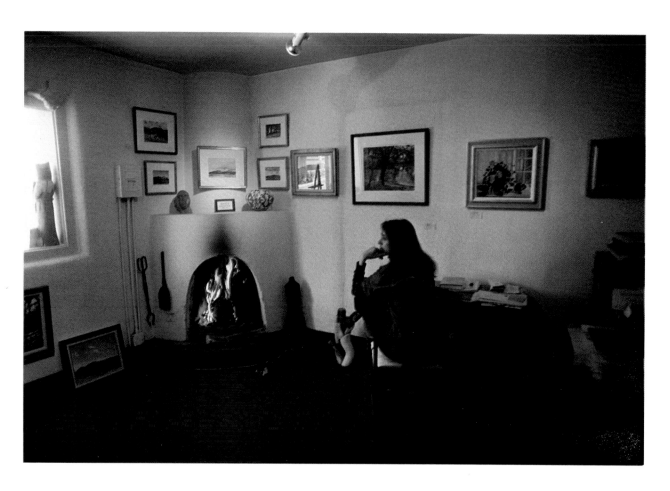

Gallery director Maria
Martinez at Ernesto
Mayans Gallery, Canyon
Road

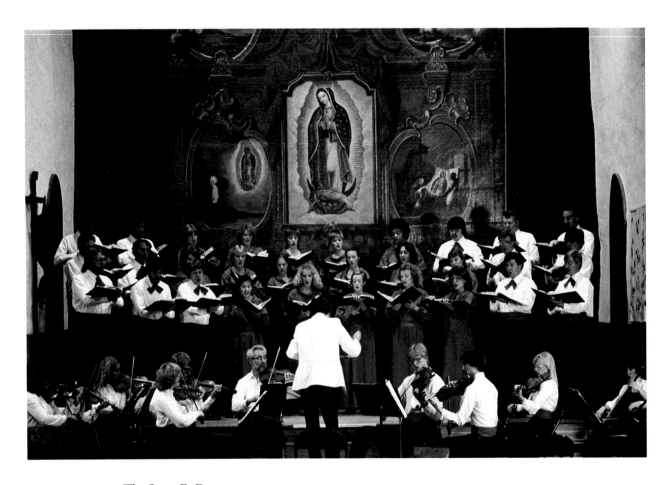

The Santa Fe Desert
Chorale performing in
Santuario de Guadalupe

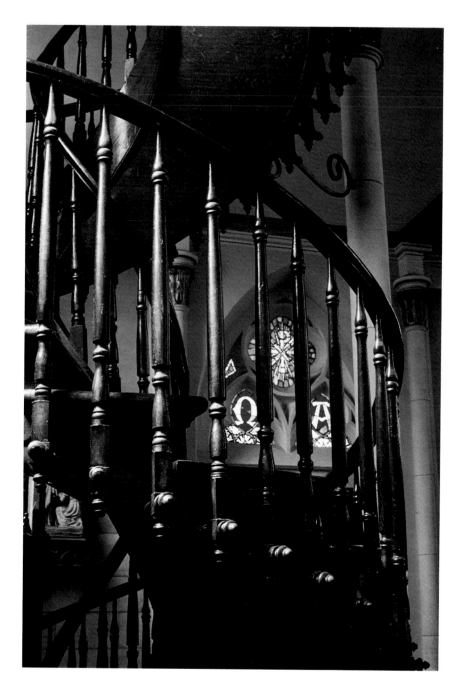

The legendary circular
staircase, Loretto Chapel

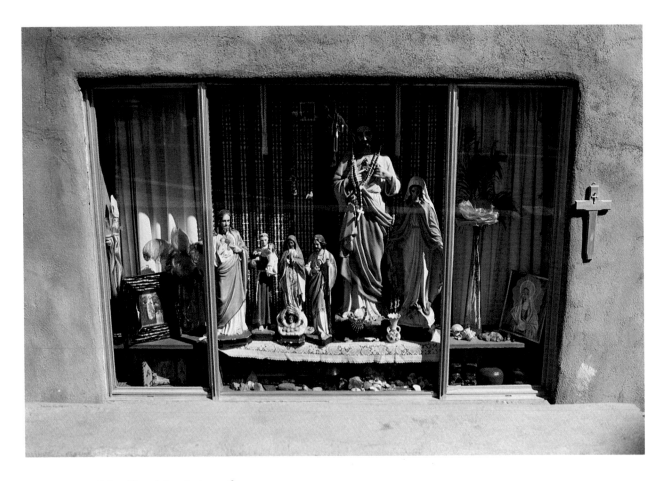

Mrs. Gurule's window of
saints

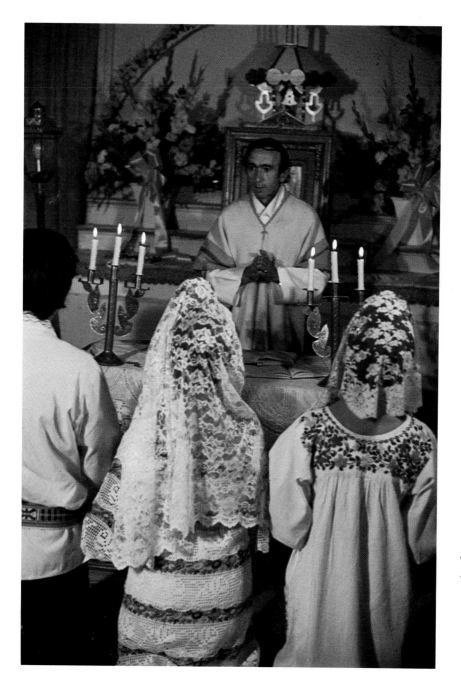

Traditional Spanish
wedding

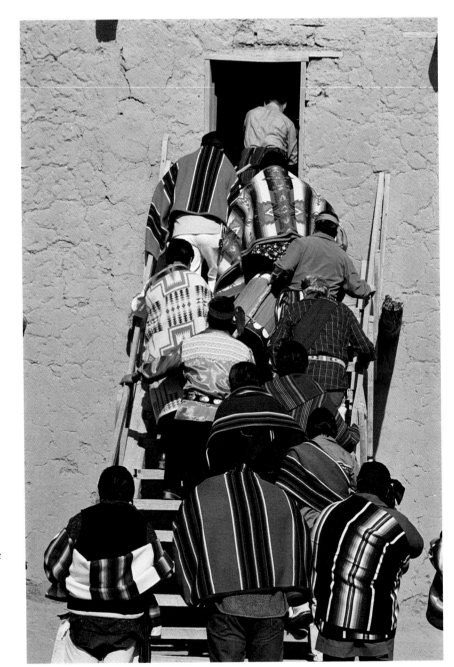

Drummers at Comanche
Dance, San Ildefonso
Pueblo

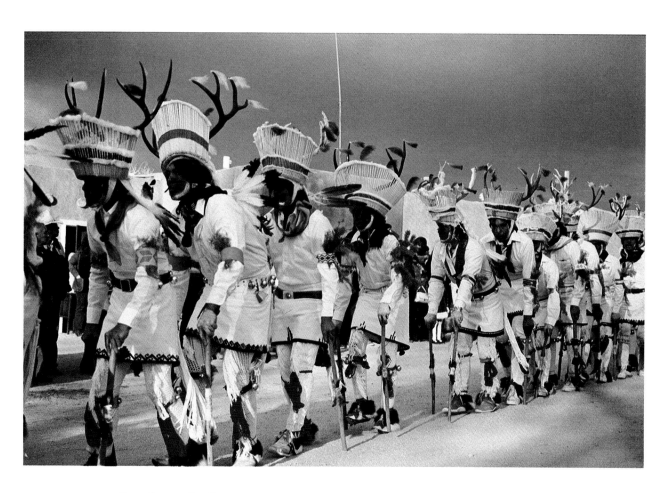

Deer Dance, San Juan
Pueblo

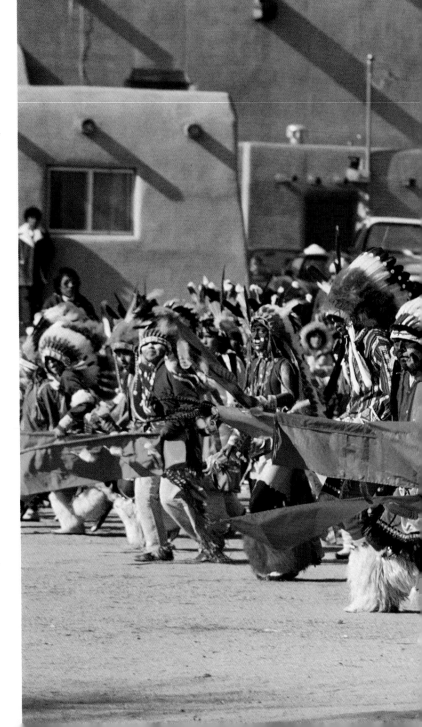

"*The Pueblos have always believed that the earth they live upon is sacred. Each stone and bush and tree is alive with a spirit like their own They live in community not only with one another but with earth and sky, with plants and animals. They believe that the orderly functioning of the universe depends on them.*"

Peggy Pond Church
The House at Otowi Bridge

Comanche Dance, San
Ildefonso Pueblo

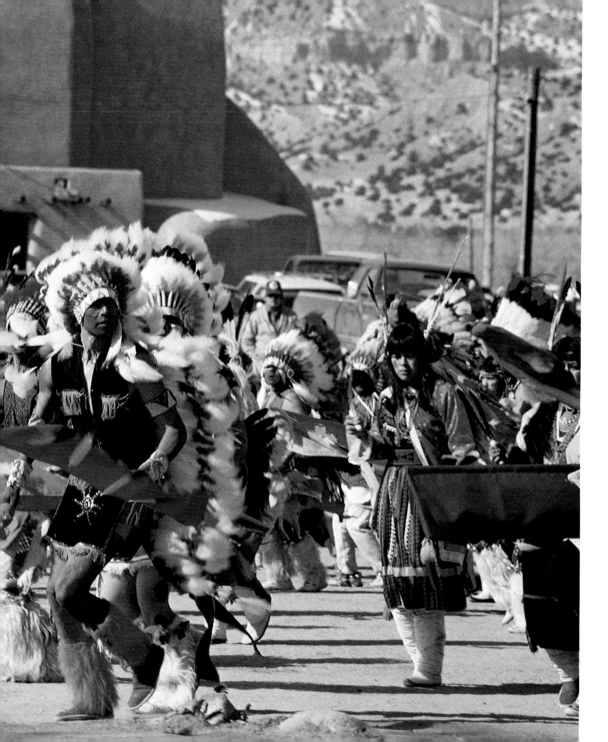

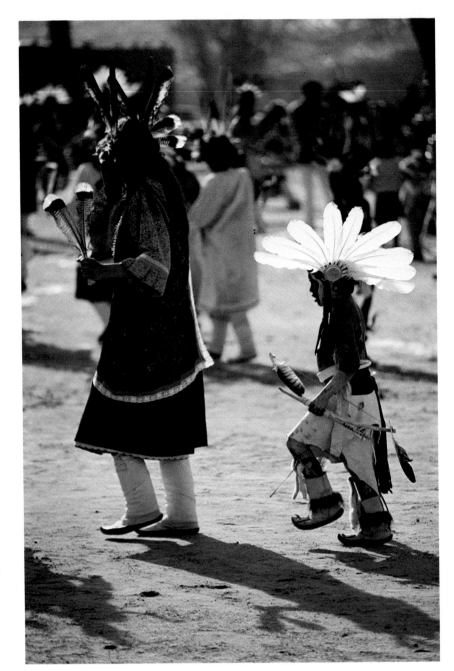

Buffalo Dance,
San Ildefonso Pueblo

40

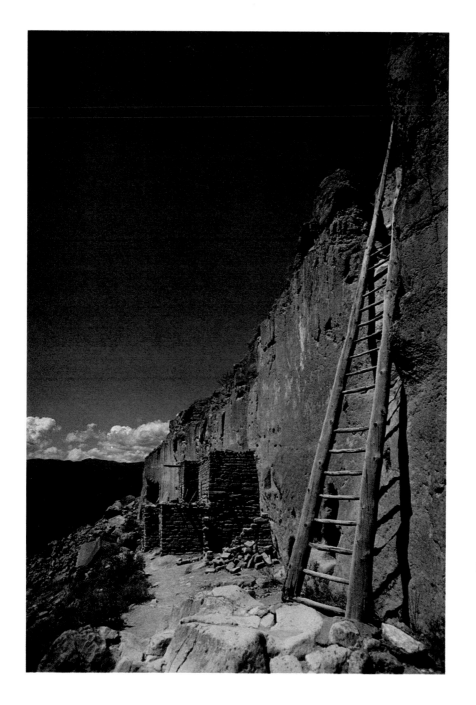

Puye Cliff Ruins

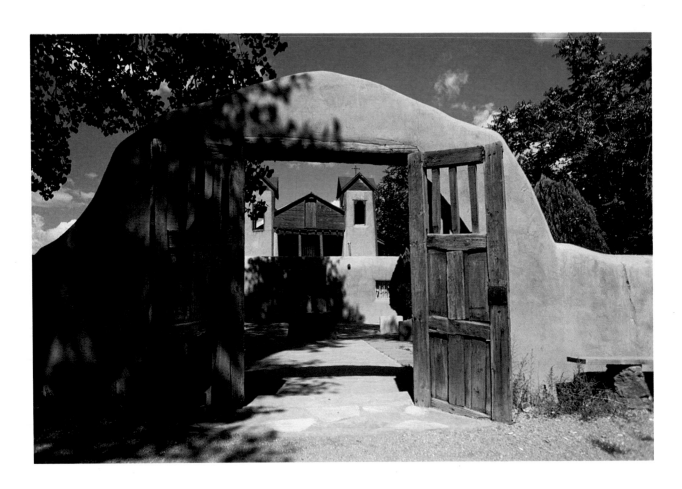

El Santuario de Chimayo,
famous for its healing dirt

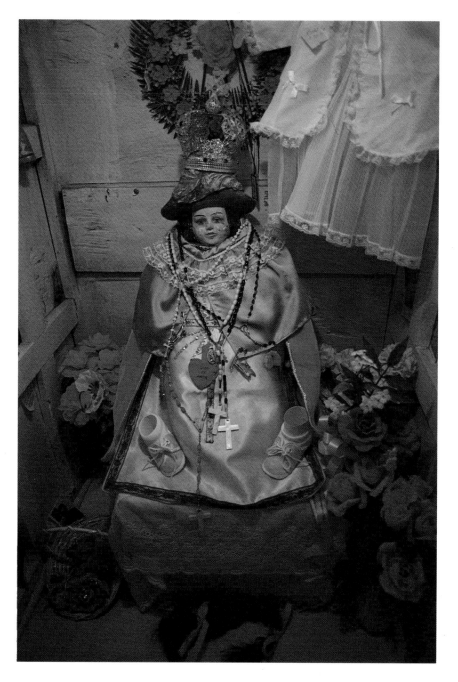

The Santo Niño, inside El
Santuario de Chimayo

43

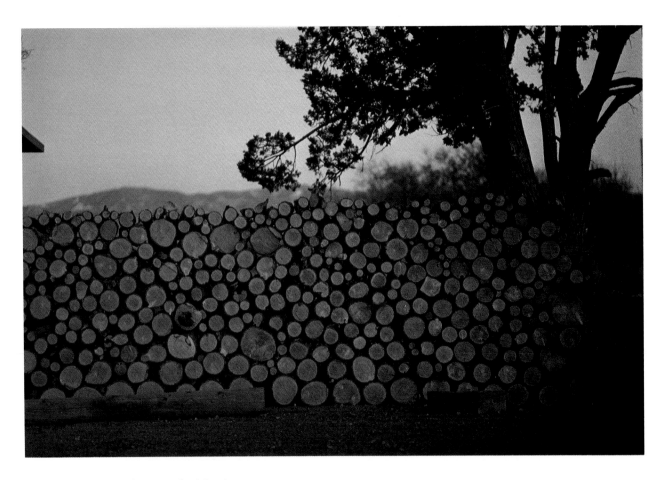

Piñon stacked for the
coming winter, near La
Cienega

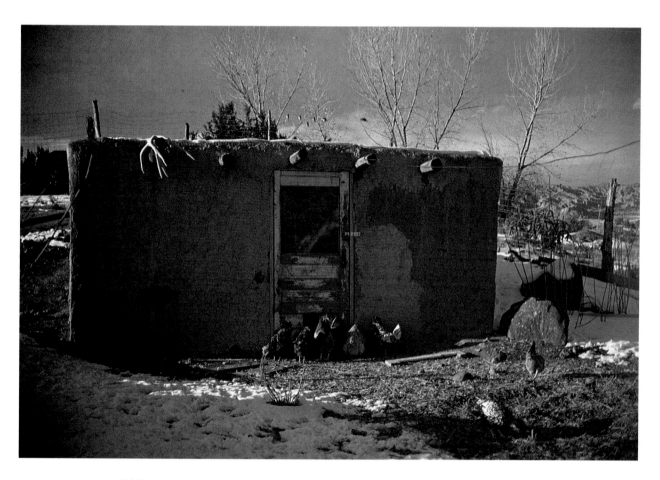

Chickens and an adobe
chicken coop, near
Chimayo

People often speak of a search for a spiritual home when they talk of coming to New Mexico. The raw, strange landscape itself exerts a powerful, mystical attraction. But the spiritual quality of the place goes deeper than landscape or light. It has to do with a sense of the past.

La capilla de la Cañada de los Alamos, Nuestra Señora de Guadalupe

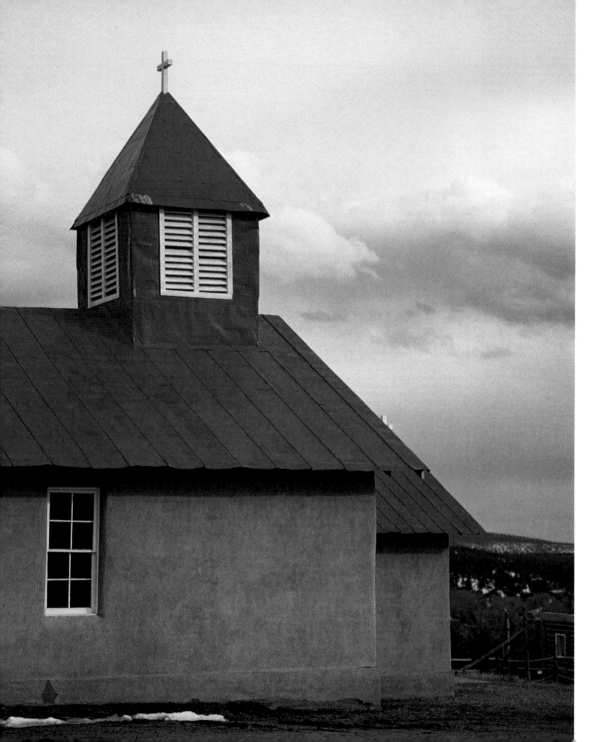

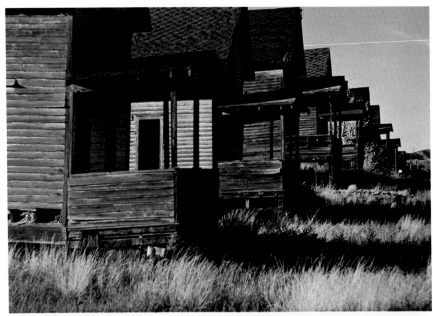

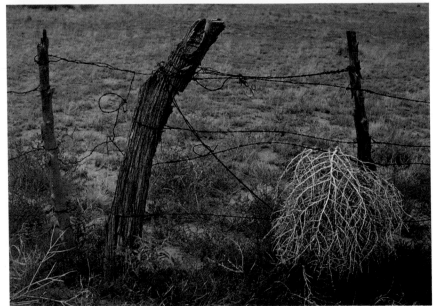

Top: Old miners' houses, Madrid. *Bottom:* Tumbleweed and barbed wire on a rural road

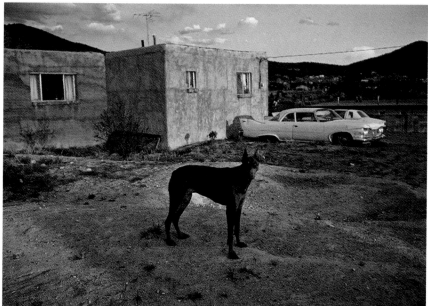

Top: Tin roof, adobe, and geranium. *Below:* A Doberman named Sienna.

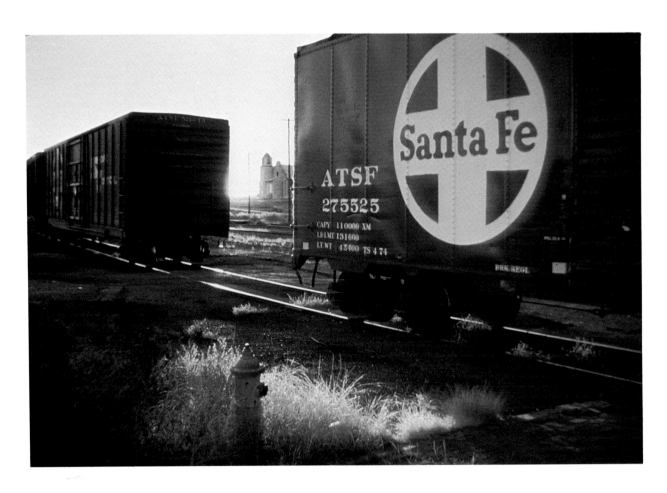

Rail siding at Lamy,
Nuestra Señora de la Luz
Church

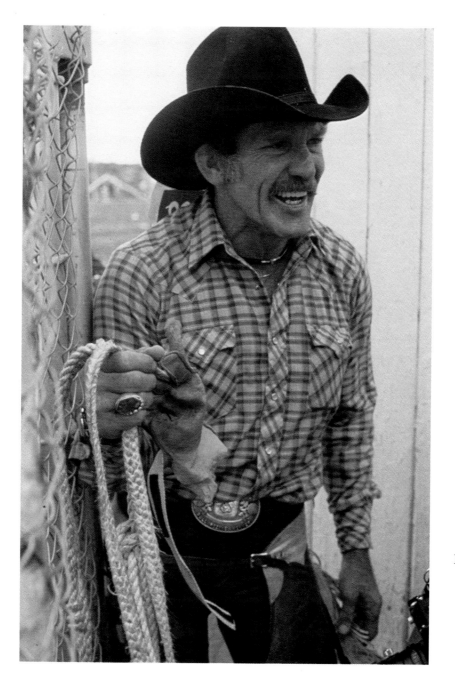

Rodeo de Santa Fe

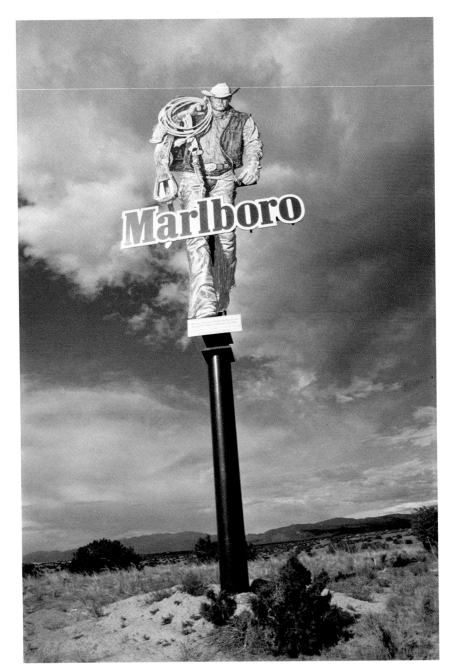

Marlboro Man on
Cerrillos Road

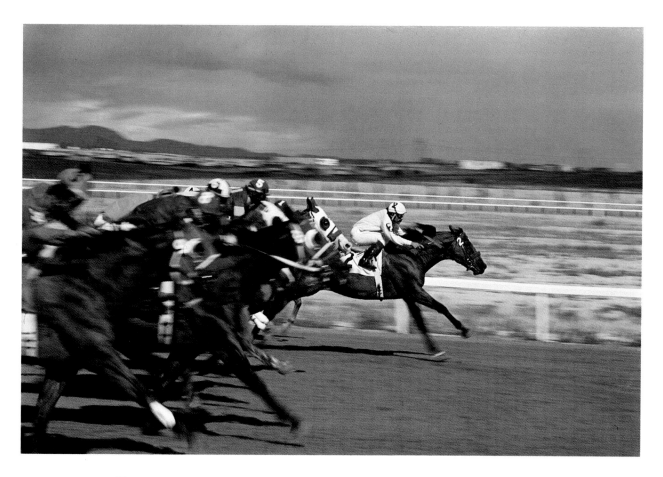

Fast start, The Downs at
Santa Fe

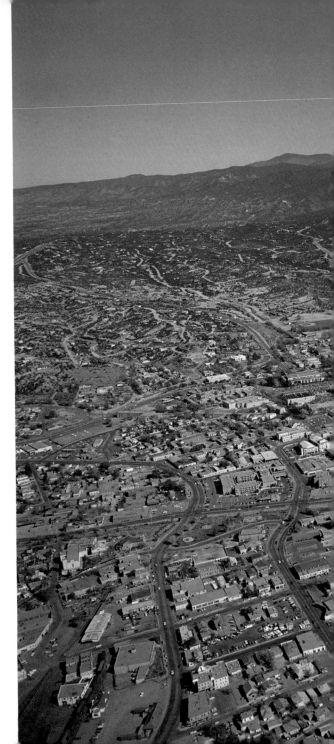

"*Now, as those blast furnace days of summer have softened at the edges, the aspens turn the color of old gold amid the ponderosas on the flanks of the mountains. The air, tangy as a margarita, reeks of wood-smoke, and the bubonic plague has gone semi-dormant once again after another season . . . Now is what Santa Feans live for, the crisp, winy days of fall.*"

John Neary
Vanity Fair

Aerial photograph—
season's first snow in the
Sangre de Cristos

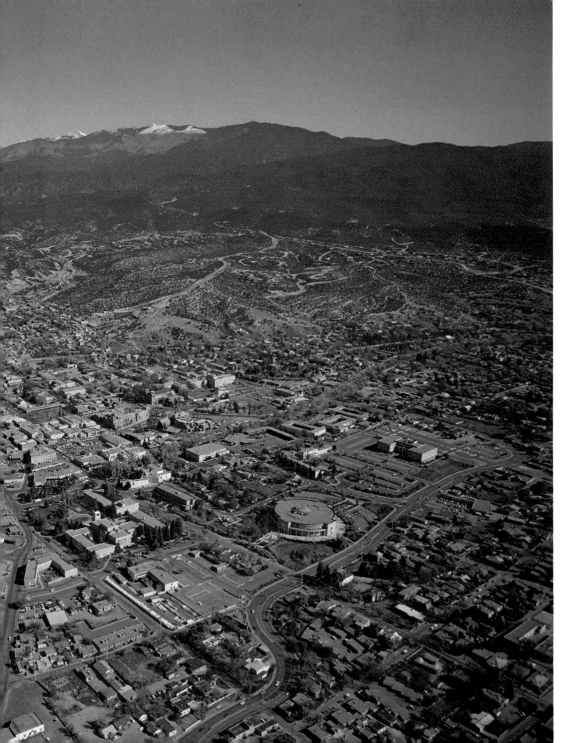

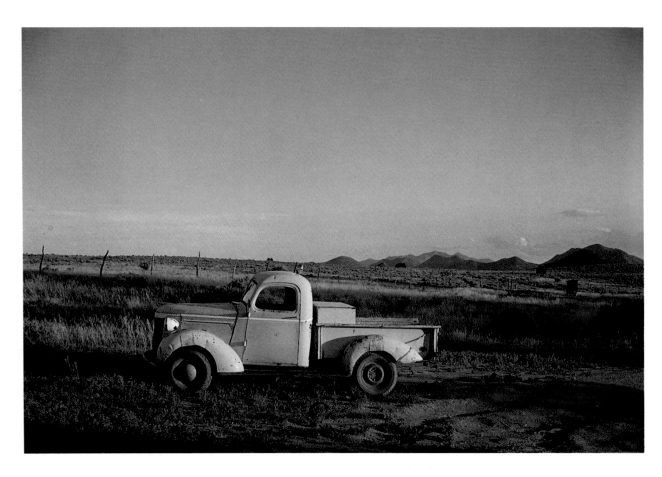

Michael Earney's Chevy
pickup at sunset

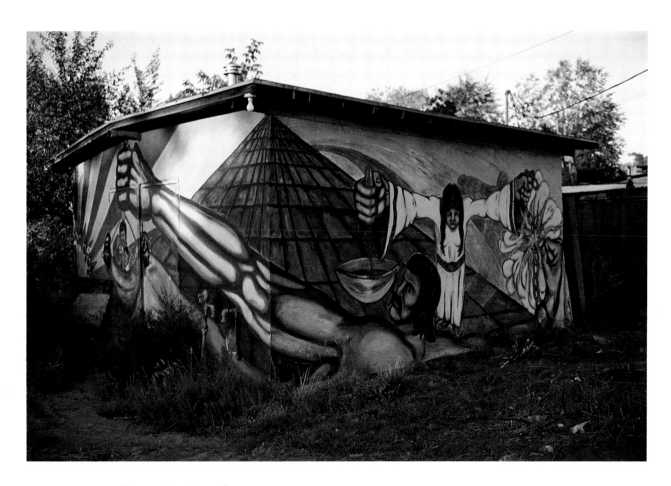

Canyon Road mural
painted by the artists of
Artes Guadalupanos

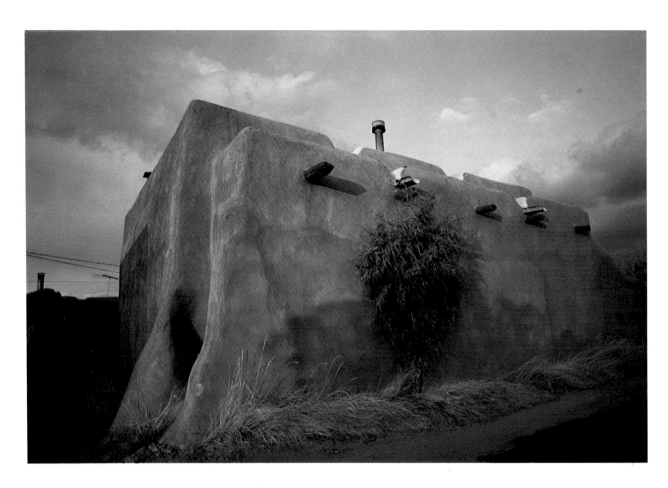

Sunset on adobe, back of
Tamotzu Gallery

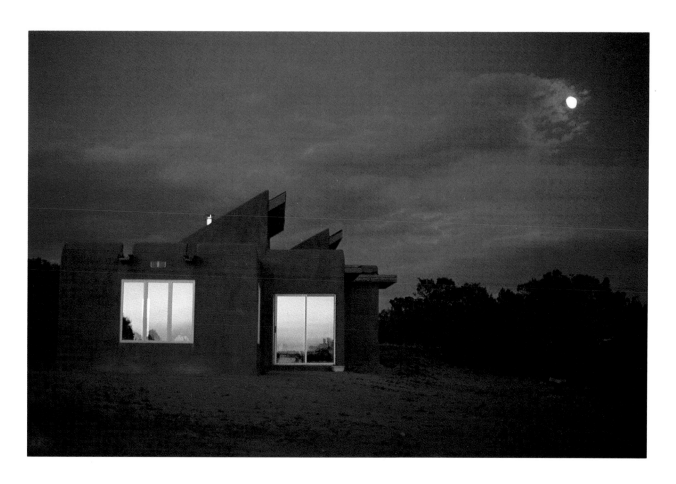

Solar home at moonrise,
Eldorado

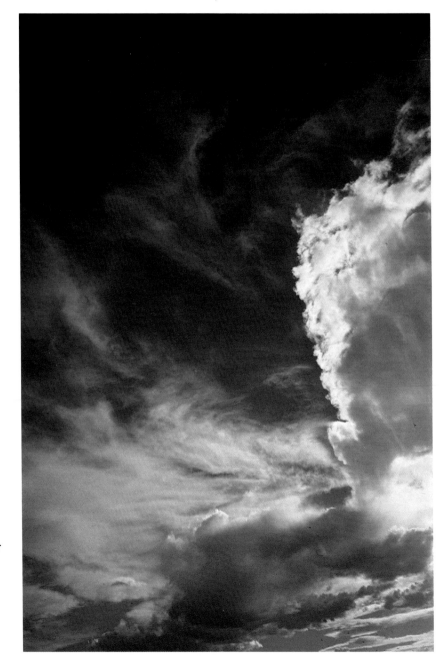

Cirrus clouds over
Agua Fria

60

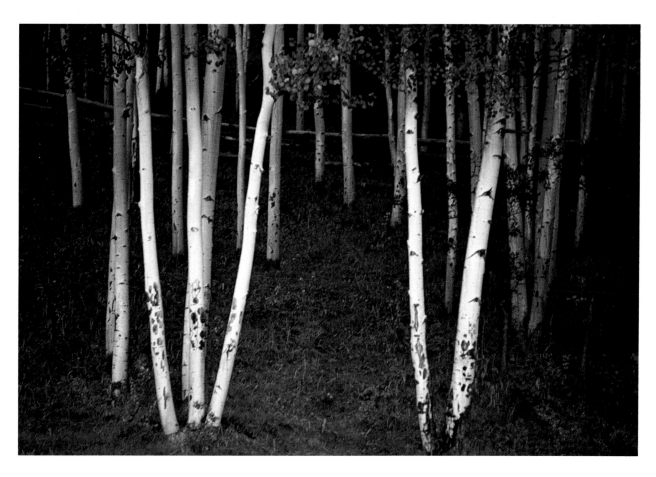

Aspen in Pecos
Wilderness, near Jack's
Creek

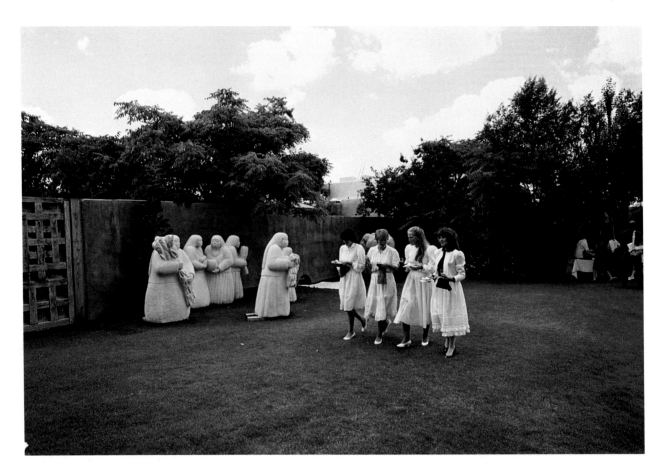

Doug Hyde sculpture
and the young ladies of
L'Ecole des Ingenues in
the Fenn Gallery gardens

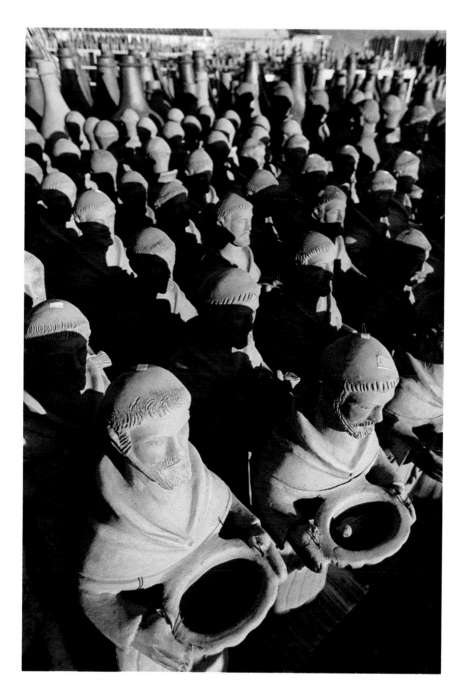

Santa Fe's patron saint,
St. Francis, in pottery,
Jackalope Pottery

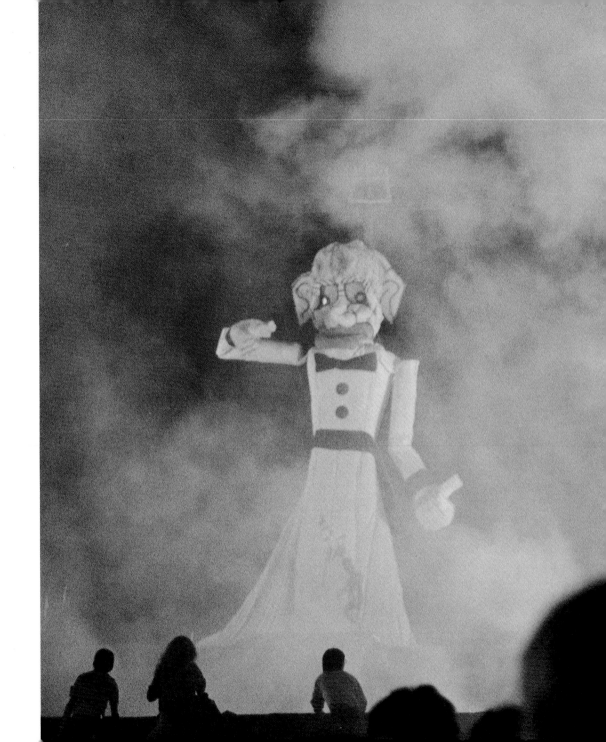

"*As the giant flames leaped into the night they were capped in the darkness by blossoms of fireworks that began to explode overhead, reports echoing off the grandstand like cannons, fireworks trailers falling like shooting stars as children screamed in delight and adults watched awestruck. . . . In another moment there was nothing left at all.*"

Robert Mayer
Midge and Decker

The burning of Zozobra—
Old Man Gloom—touches
off Fiesta

65

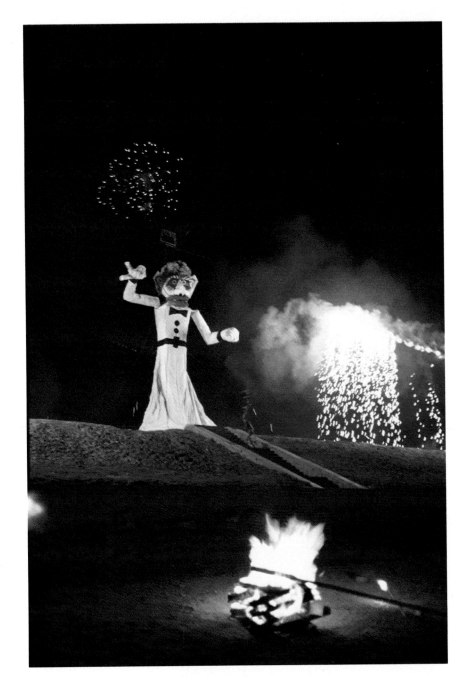

Zozobra with
fireworks

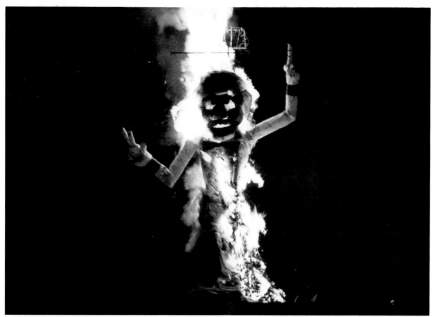

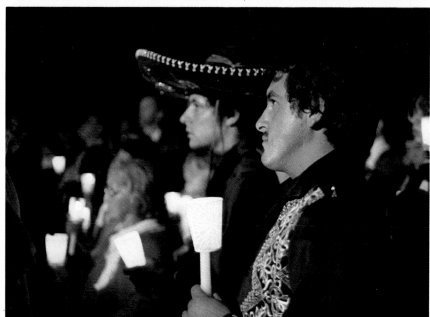

Top: Last seconds of Zozobra. *Bottom:* Fiesta procession to the Cross of the Martyrs.

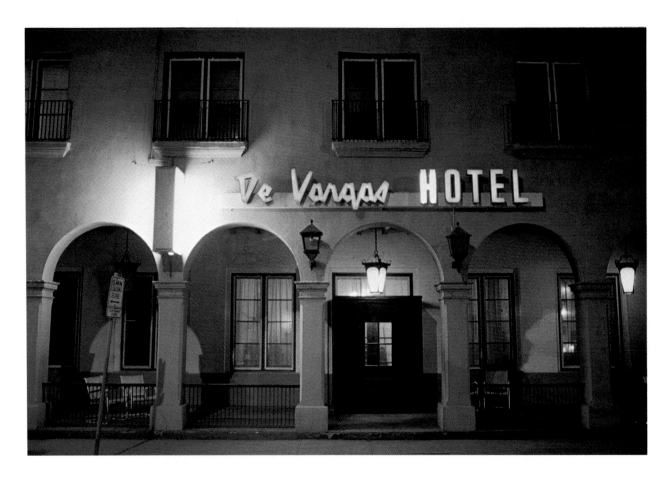

The old De Vargas Hotel

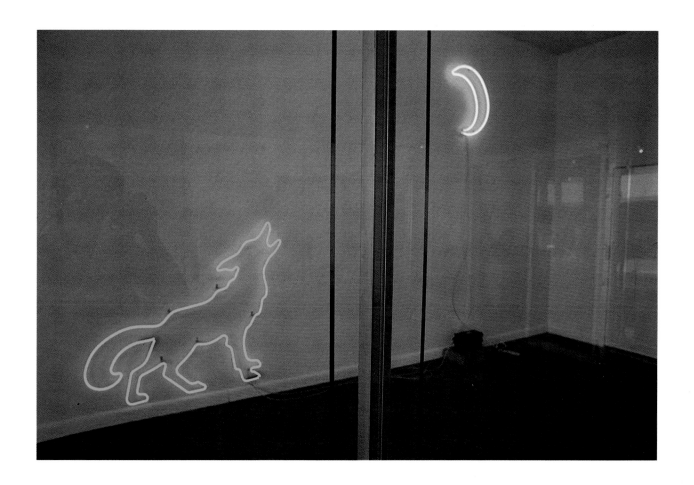

Neon coyote howling at
the moon. By Chigger
King

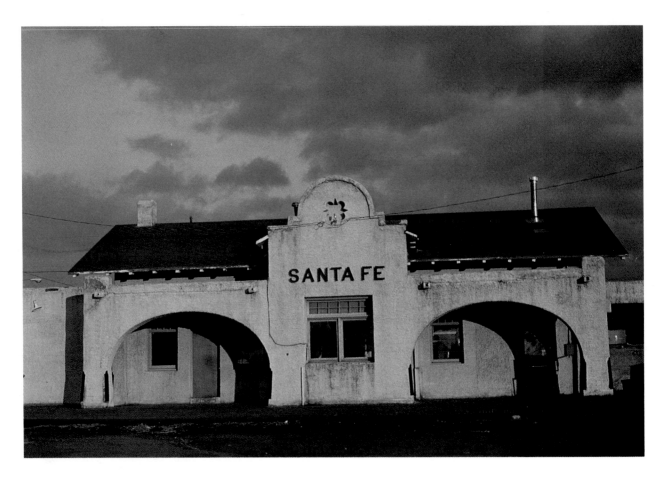

The Santa Fe Depot

William Clark is a freelance writer/photographer and independent filmmaker whose work has appeared in a variety of national and regional publications, including *Newsweek, The New York Times, ARTnews, Rocky Mountain Magazine,* the *Albuquerque Journal* and the *Denver Post.* His photographs are distributed by Sipa Press, Paris, and Sipa/Black Star, New York.

Edward Klamm is director of FotoWest and a freelance photojournalist. He is currently working with 13 other photographers on a project called "A Portrait of Santa Fe." Other projects have included urban Native Americans and dancers. His work has appeared in the books, *Cowboy: The Enduring Myth of the Wild West* (Stewart, Tabori & Chang, NYC), *Dustoff,* (American Indian Arts Press), and such periodicals as *Via 7* (MIT Press), *Newsweek, Outside, Time* and *U.S. News & World Report.* He is represented in New York by Black Star.

Jack Parsons is a documentary filmmaker and stills photographer who has produced and shot numerous 16mm documentaries, among them award-winners such as *Luisa Torres, Rio Grande, Slim Green,* and *La Musica de los Viejos.* He is the co-author and photographer of the book *Land and Cattle* and has recently completed the cinematography for an hour-long PBS documentary *Genbaku Shi* ("Killed by the Atomic Bomb") on the American victims of the atomic bomb blast at Hiroshima.

Bernard Plossu is a photographer who moved from France to New Mexico in 1977 where he now resides in Santa Fe with his wife Kathy and son Shane. A book of his photographs, *New Mexico Revisited,* was published in 1983 by University of New Mexico Press. He works in both color and black and white (in black and white using only the 50mm lens). His images are in the collections of the Center for Creative Photography, Tucson, Arizona; the Amon Carter Museum, Fort Worth, Texas; and the George Eastman House, Rochester, New York.

Aerial photographer **Paul Logsdon** has captured prehistoric ruins, geologic wonders, manicured fields, and urban landscapes from his small airplane, using a hand-held camera. He is based in Santa Fe.

PHOTOGRAPHY CREDITS

WILLIAM CLARK: Pages 4, 7, 16, 20, 21, 22, 24, 25, 28, (top), 34, 37, 43, 57, 64-65, 69. EDWARD KLAMM: Pages 10, 12, 13, 15, 18-19, 23, 26-27, 29 (top right, bottom left), 32, 33, 44, 51, 52, 53, 58, 62, 63, 66, 67, 68, 70, 72, back cover. JACK PARSONS: Pages 3, 17, 29 (top left, bottom right), 35, 36, 38-39, 40, 45, 49, 50, 56, 61. BERNARD PLOSSU: front cover, Pages 8-9, 11, 14, 25 (bottom), 30, 31, 41, 42, 46-47, 48, 59, 60. PAUL LOGSDON: Pages 54-55.

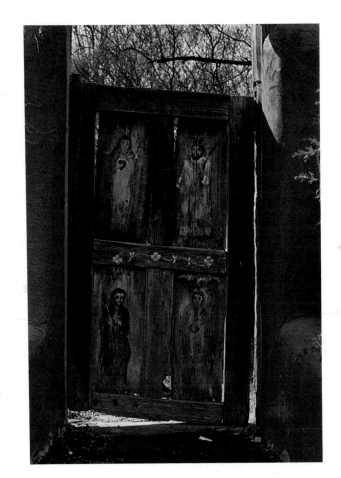

Gate on Camino del
Monte Sol. Artist Shirley
Mudd painted the Santos
to convey a blessing to all
who pass by—joggers,
walkers, cyclists, and
drivers.